STONE CATS

To Kim,
 Hoping this inspires
you. Sorry you couldn't
make this trip to D.C.
 Love,
 Maura

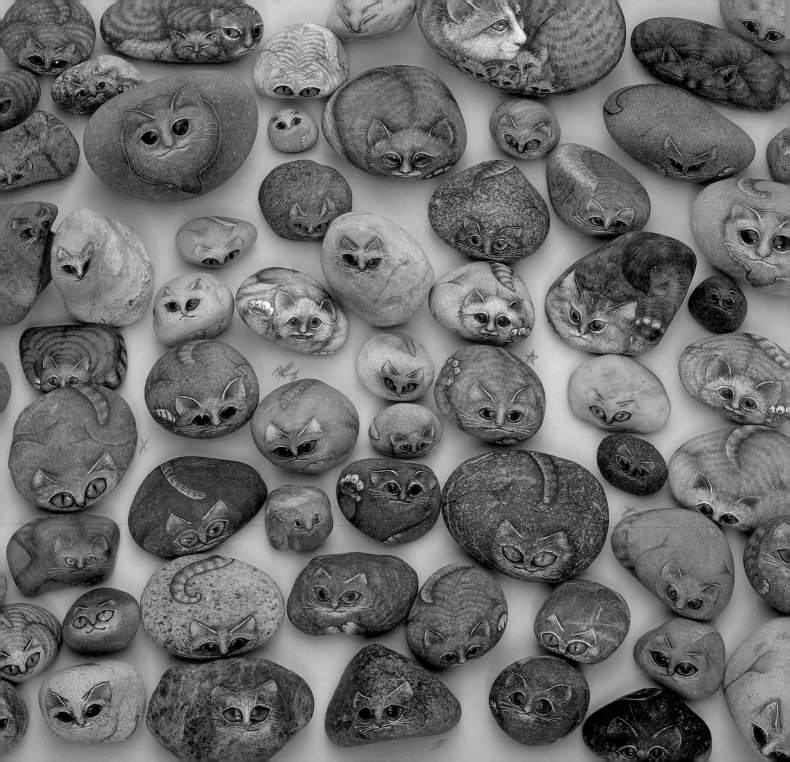

STONE CATS

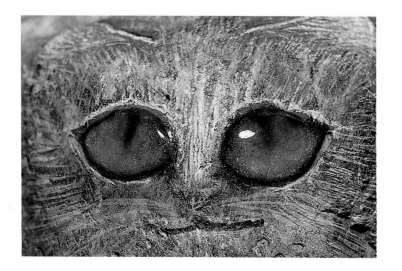

NAGATA YOSHIMI

NEW YORK · WEATHERHILL · TOKYO

First edition, 1993

Published by Weatherhill, Inc.
420 Madison Avenue, 15th Floor
New York, N.Y. 10017

Stone Cats is based on *Ishikoro no Dōbutsutachi* by Nagata Yoshimi,
published by Unsodo Publishing Company, Ltd., Tokyo,
Japan, in 1988. The author has created new stone cats and
supervised additional photography for the English version.

Photographs by Sugimoto Masami

© 1993 by Weatherhill, Inc.

Printed in Mexico

Library of Congress Cataloging in Publication

Nagata, Yoshimi, 1943–
[Ishikoro no dōbutsutachi. English]
Stone cats / by Nagata Yoshimi. — 1st ed.
 p. cm.
 ISBN 0-8348-0279-1 : $14.95
 1. Rock craft. 2. Cats in art. I. Title.
 TT293.N3313 1993
 745.59—dc20 93-18223
 CIP

CONTENTS

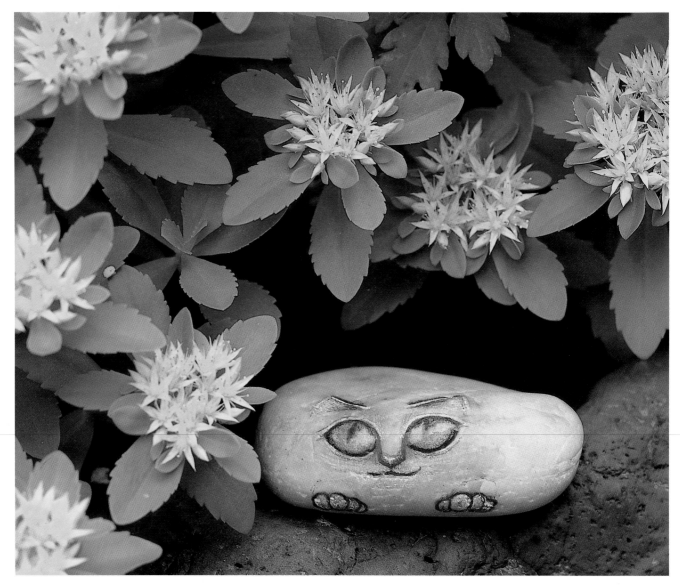

FOREWORD

One bright morning I found myself walking along the seashore of Suma Bay when I noticed the pebbles at the shoreline, glittering like jewels in the morning sun as they were tugged back and forth by the waves. I picked up a handful and rolled them around in my palm. They seemed so familiar, and suddenly I realized why. As a boy, I used to lie on my back in a field, gazing at the puffy cumulus clouds that endlessly mutated in a myriad human and animal shapes as they passed overhead. Looking down at the stones in my hand, I saw the same ever-changing forms, the same possibilities waiting to be born.

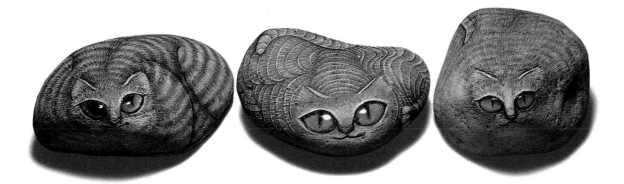

I brought the stones home with me, and as I traced their scratches and cavities, bends and bumps with a pencil, the forms hidden within them emerged. When I painted in eyes, they were transformed into cats, looking back at me with lively expressions. Who would ever have thought that these ordinary stones, these pebbles that I had kicked and scuffed until today, would provide such inspiring creative material?

It took many long eons for these pebbles to assume the shapes they have today, and many more changes await them still. The marvel of creation abides in even the humblest of nature's products; we have only to learn to see it. Each stone is an absolute original, with a form, shape, and color as distinctive as the personality and character of each of the cats that, for a short time, they have agreed to incarnate — to our imagination's delight.

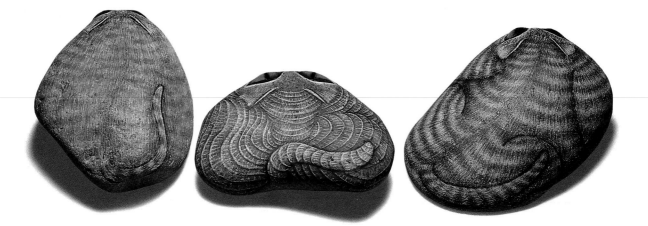

Stone Cats

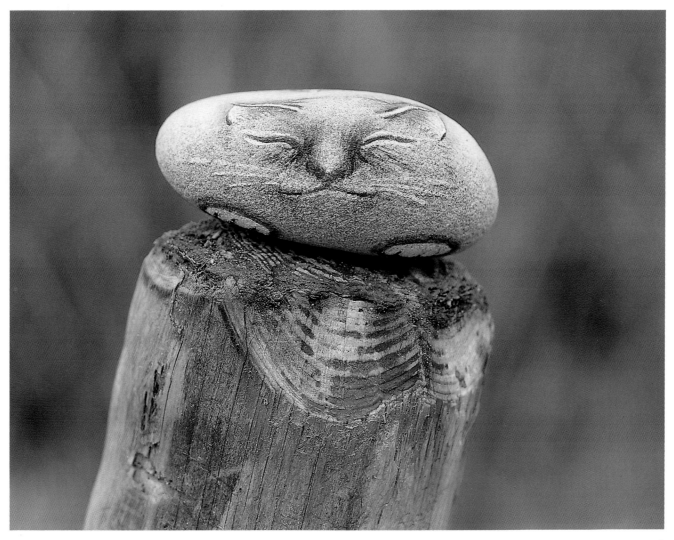

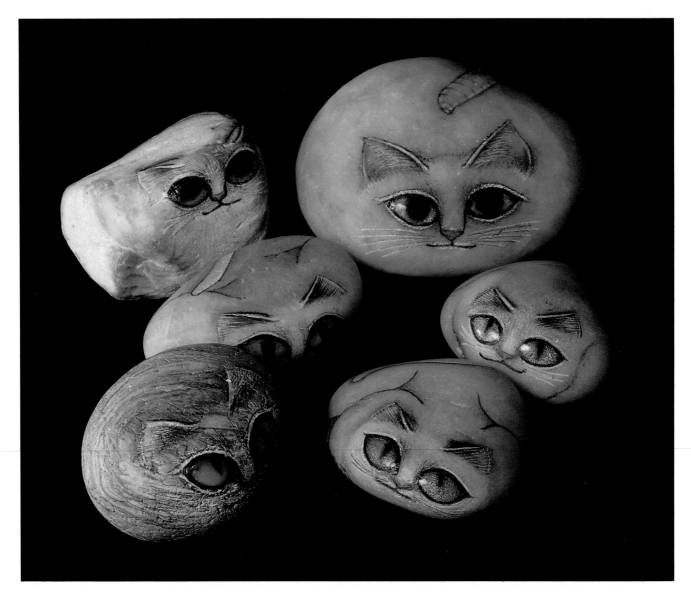

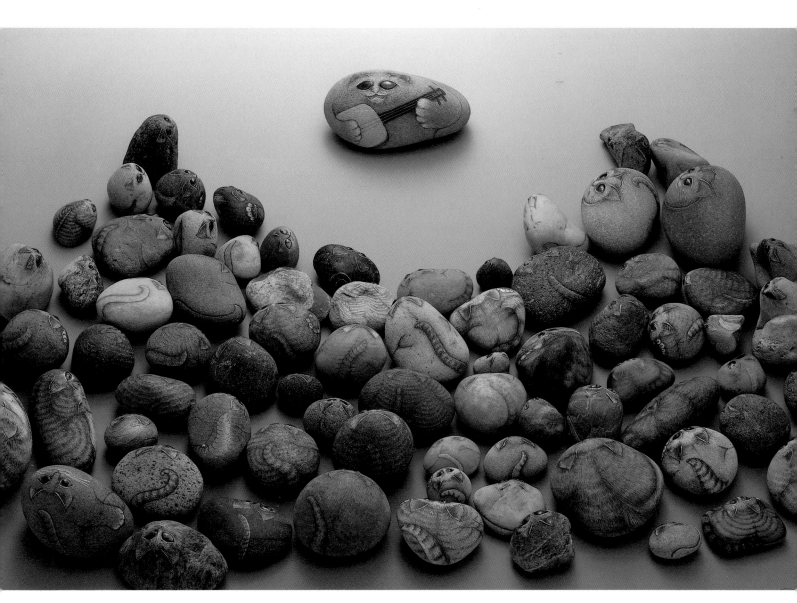

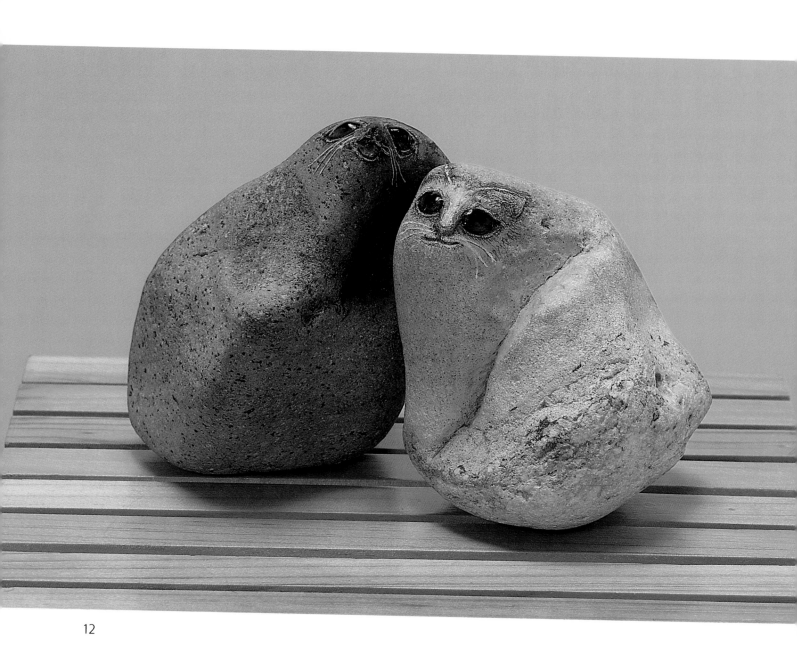

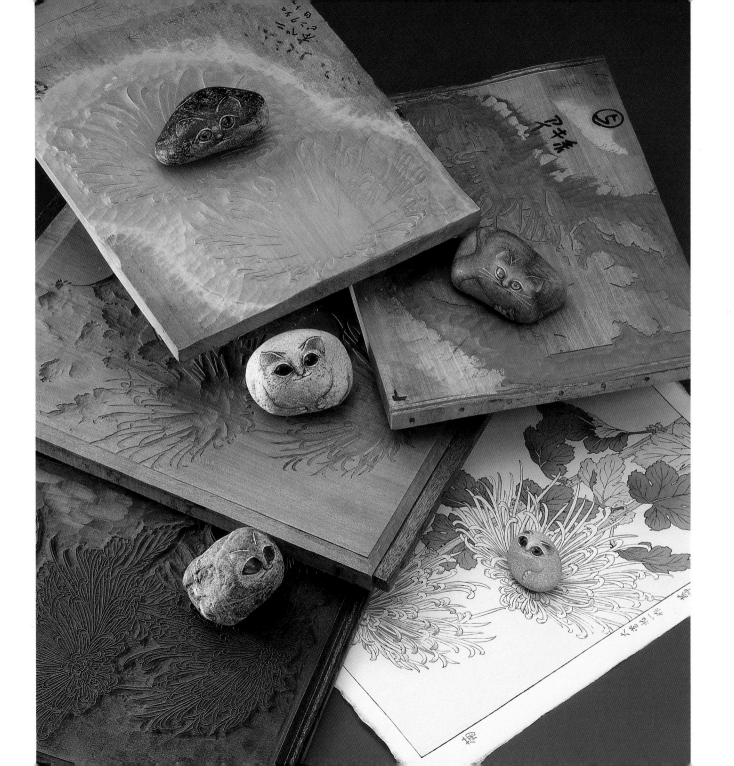

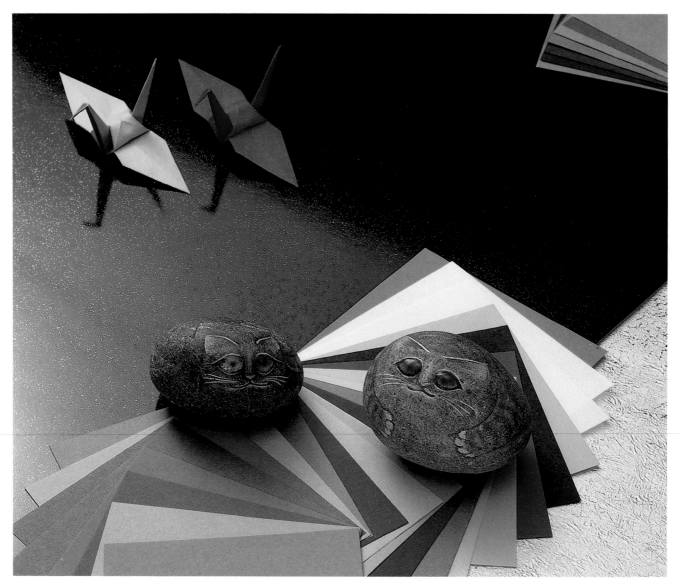

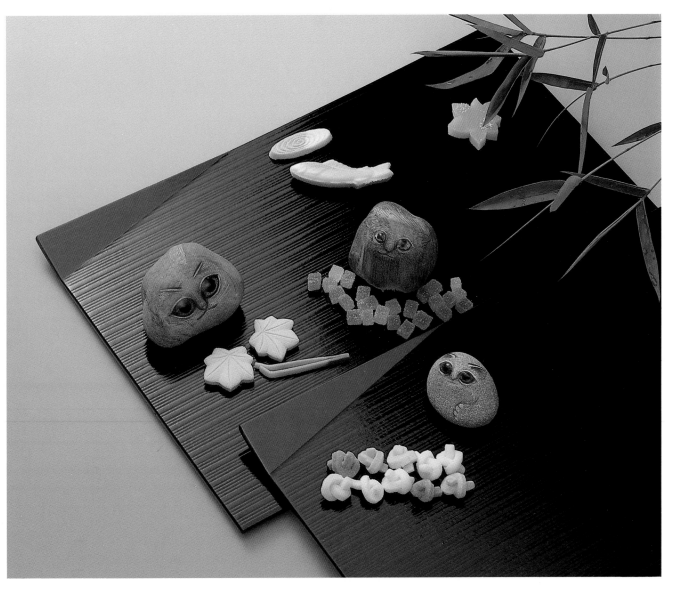

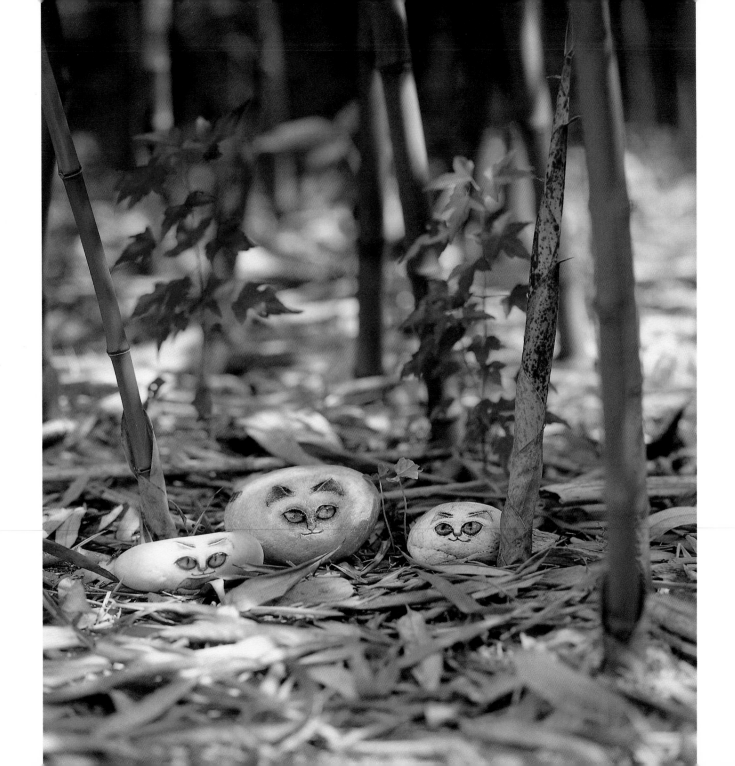

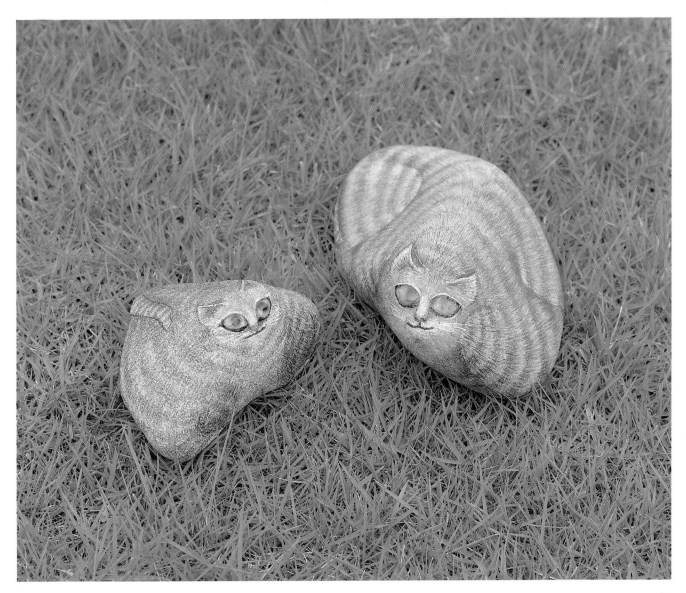

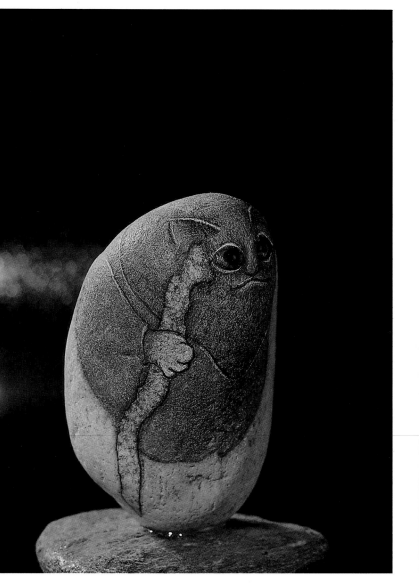

18

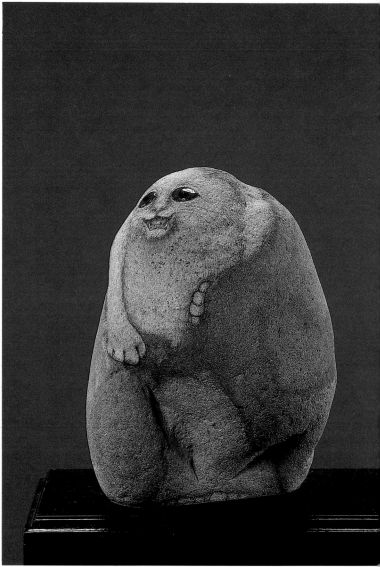

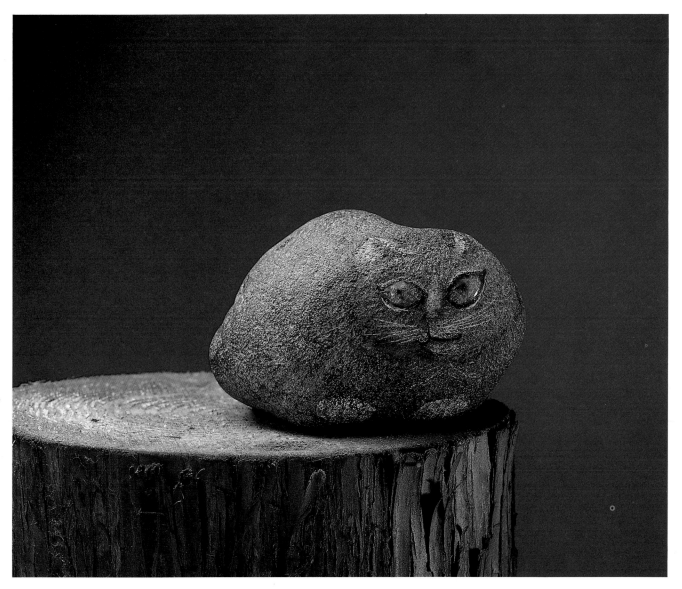

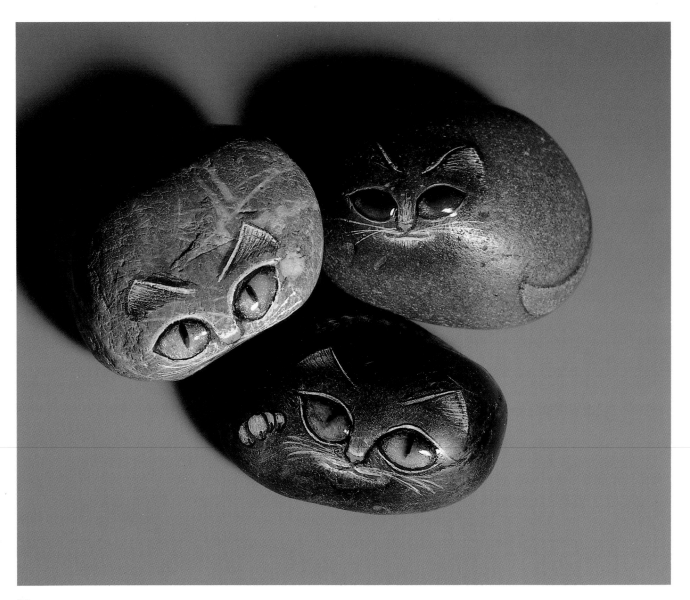

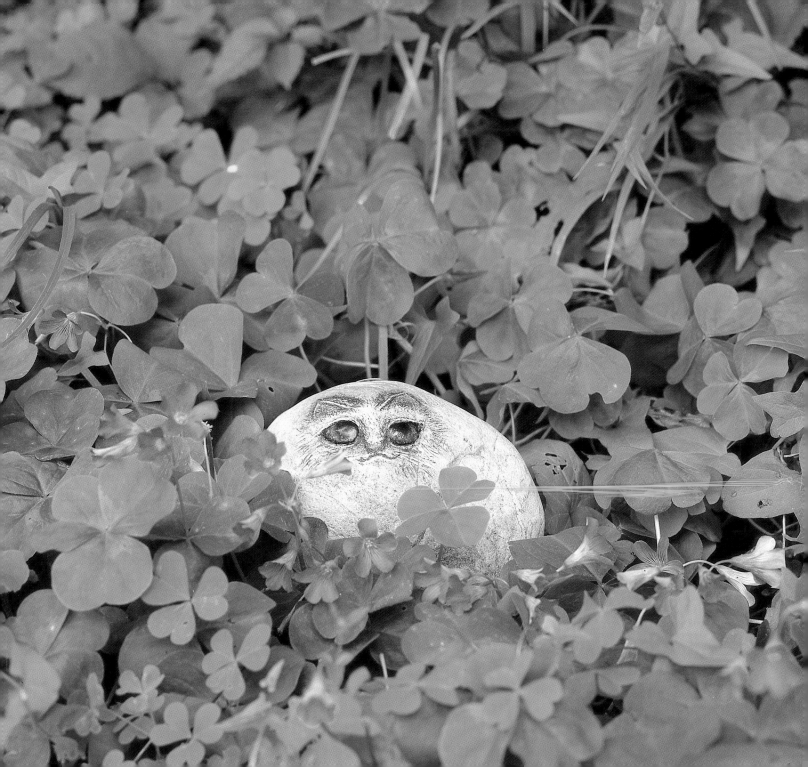

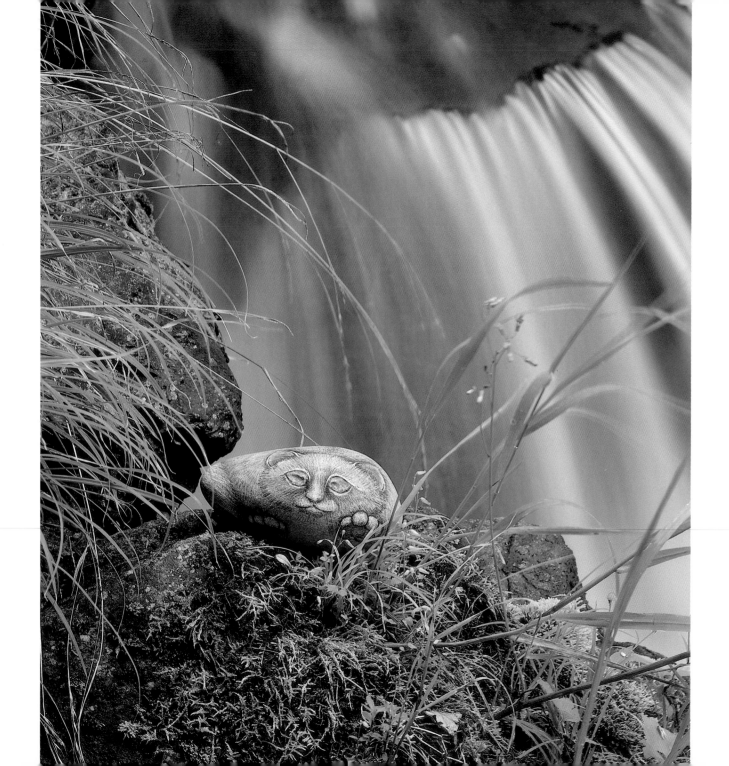

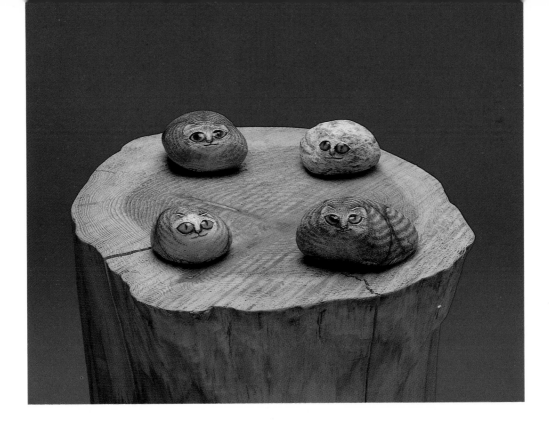

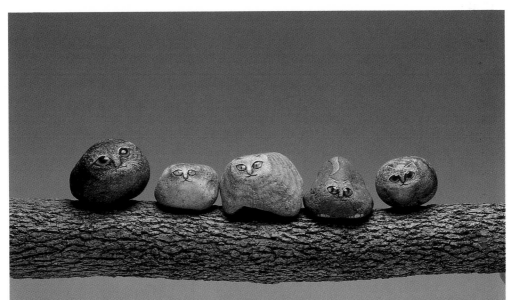

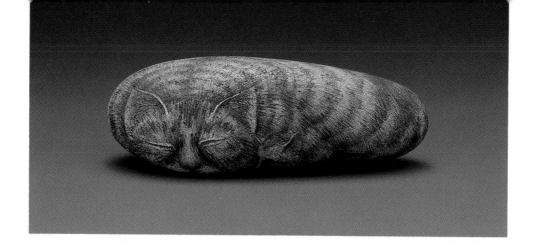

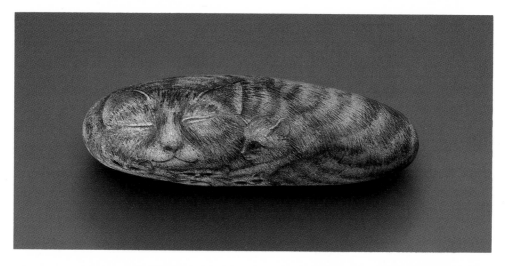

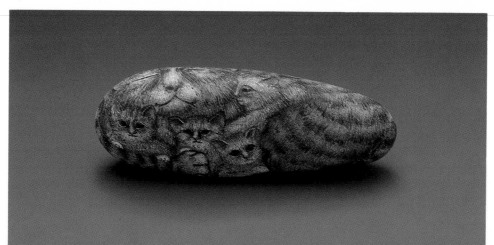

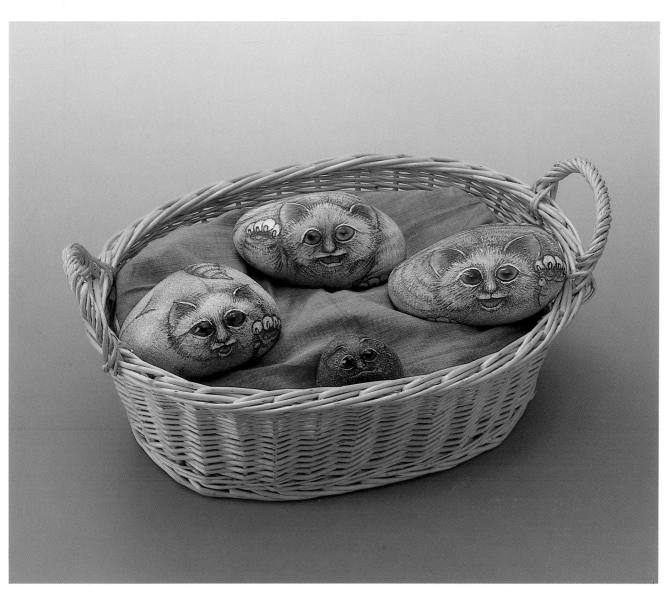

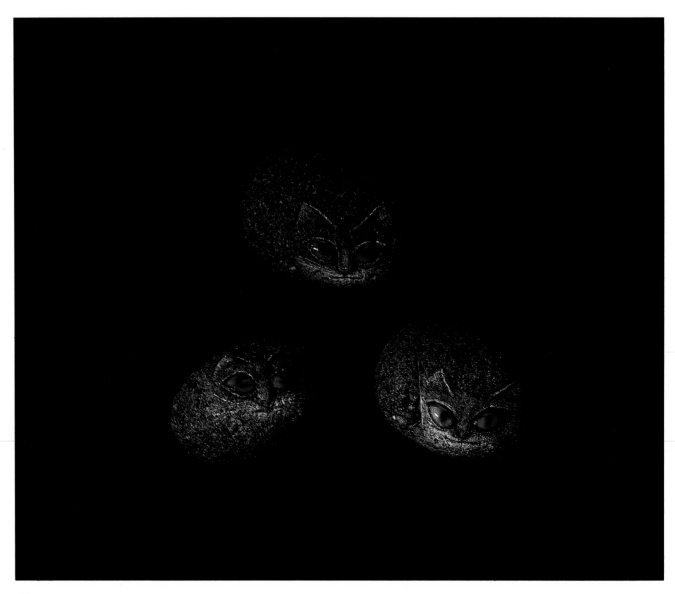

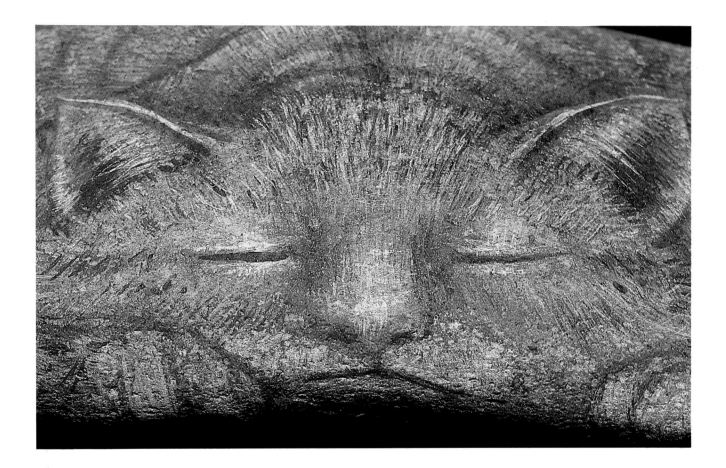

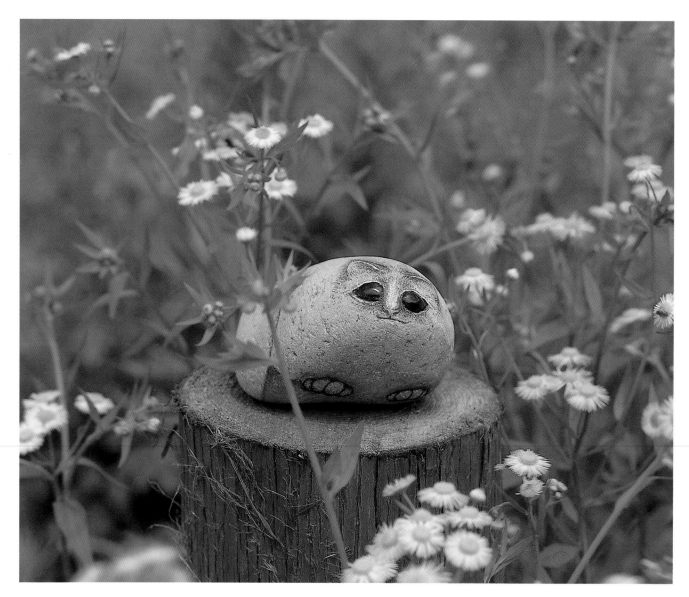

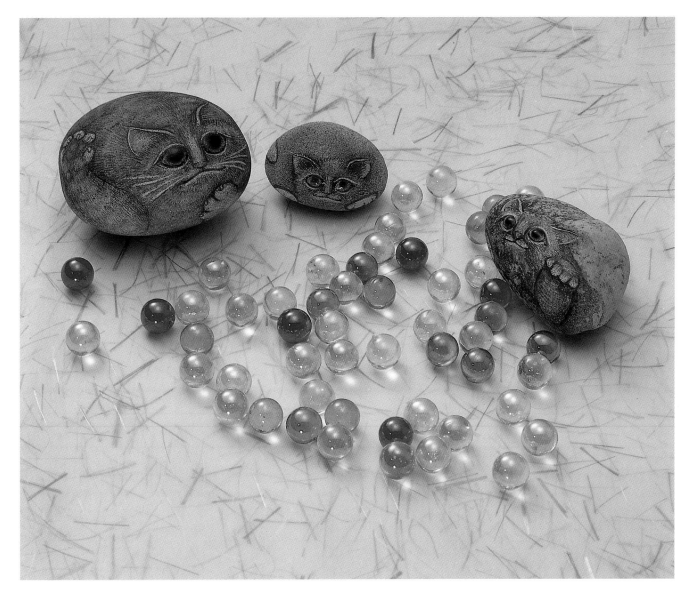

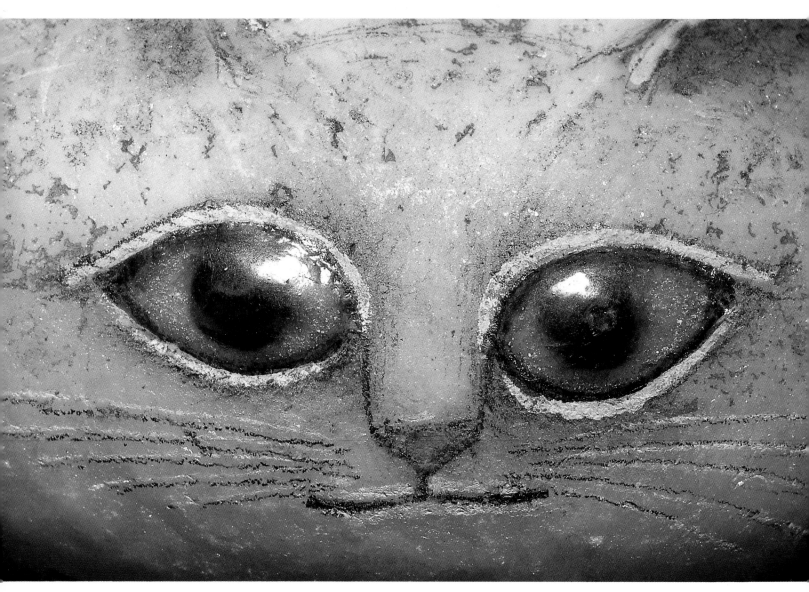

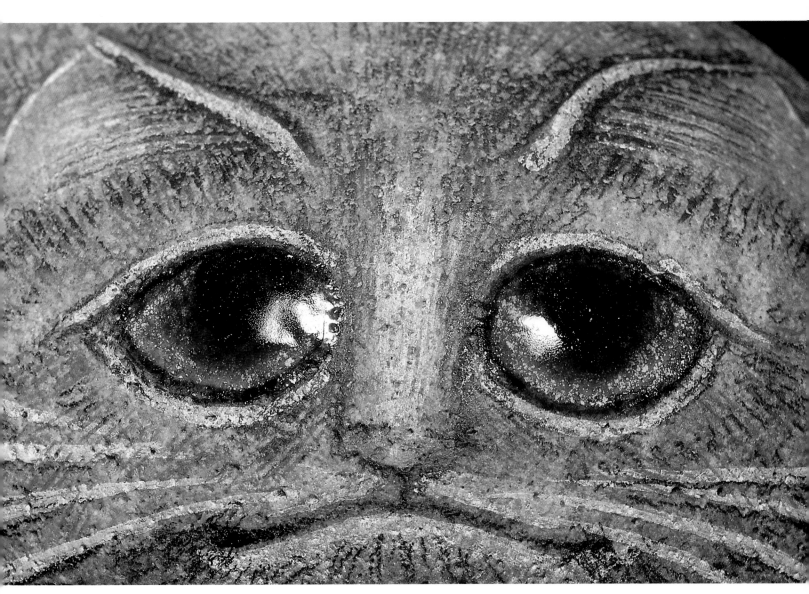

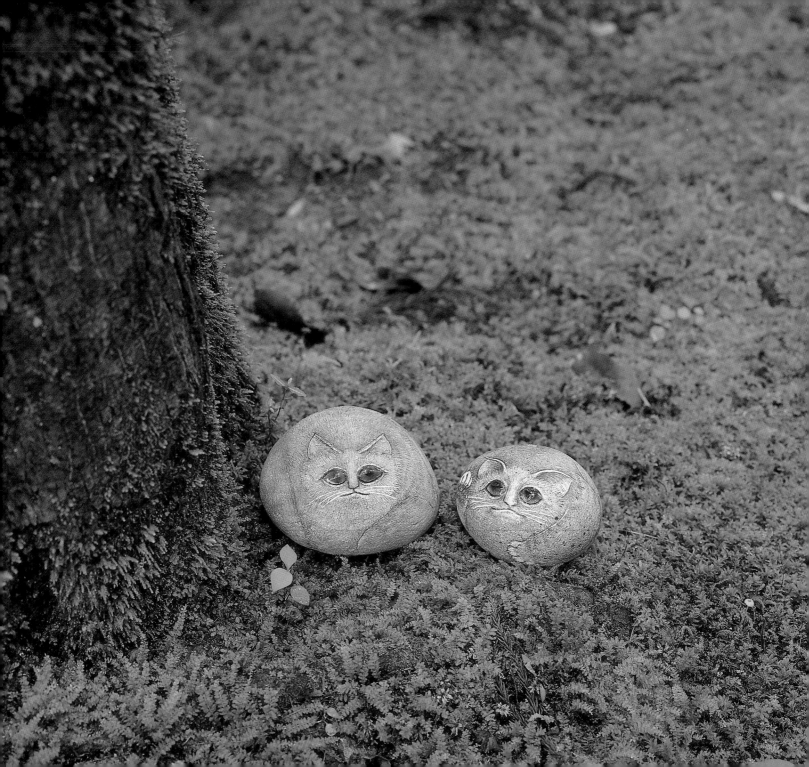

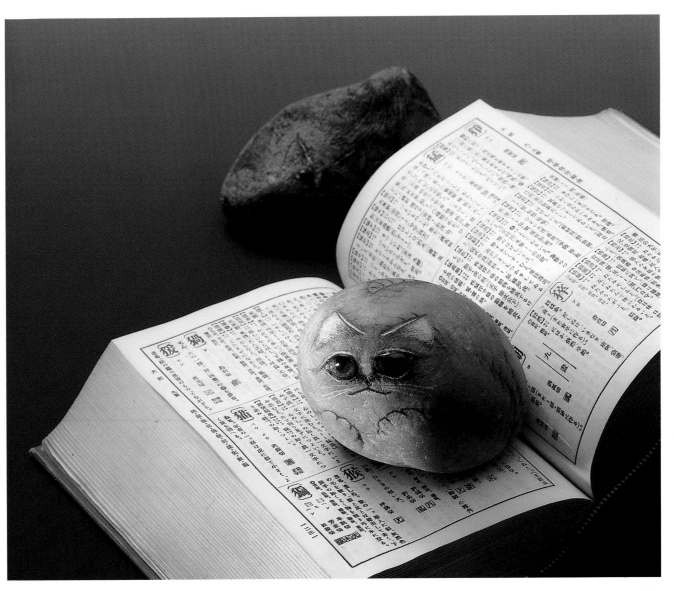

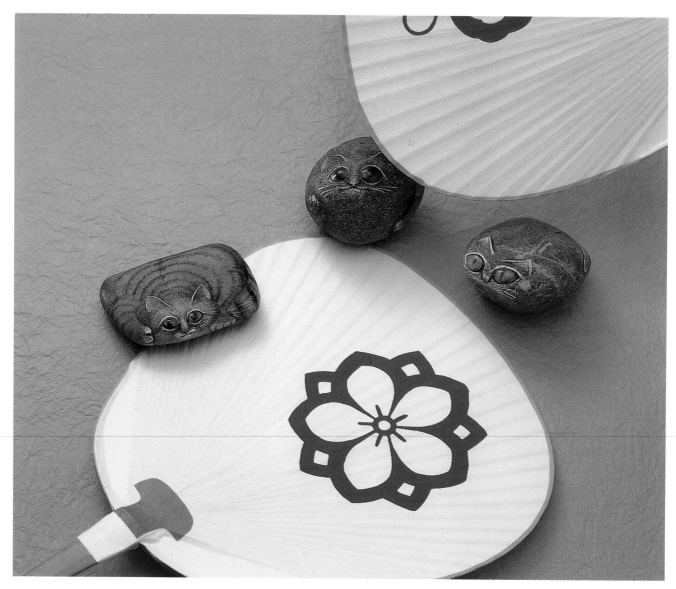

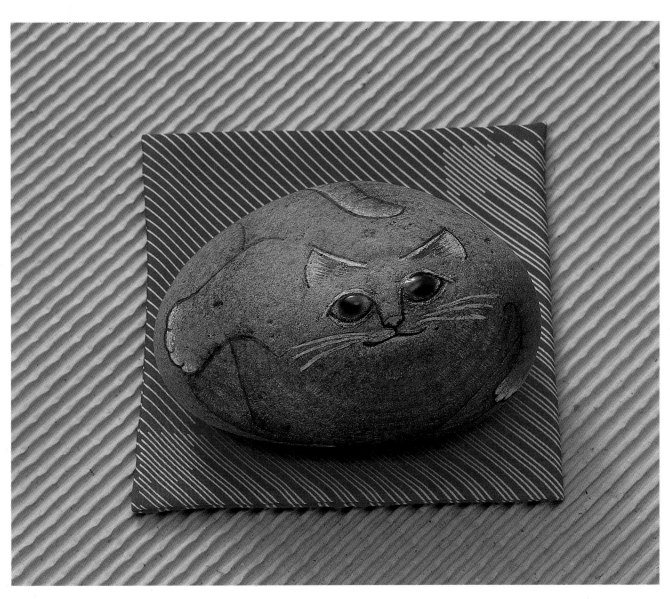

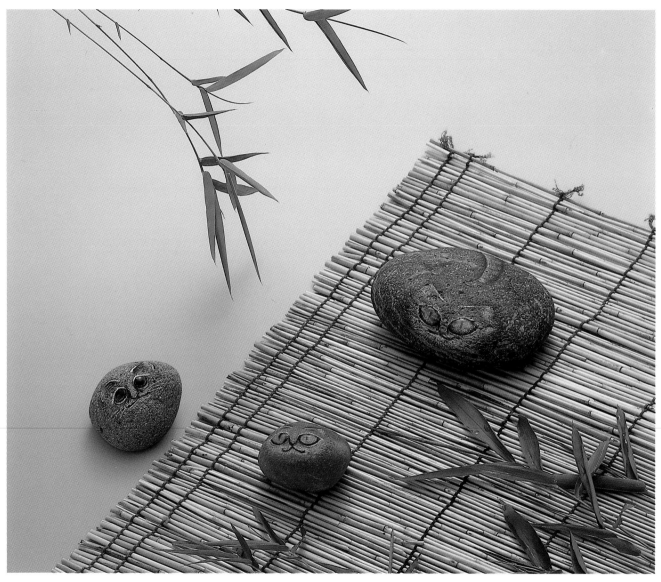

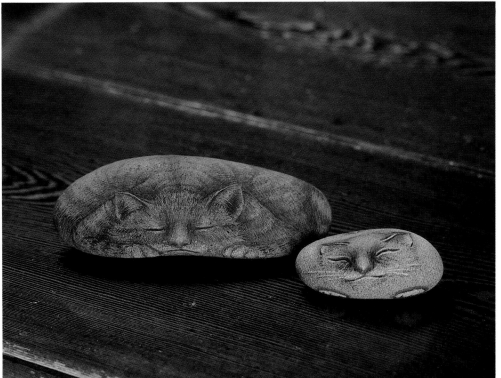

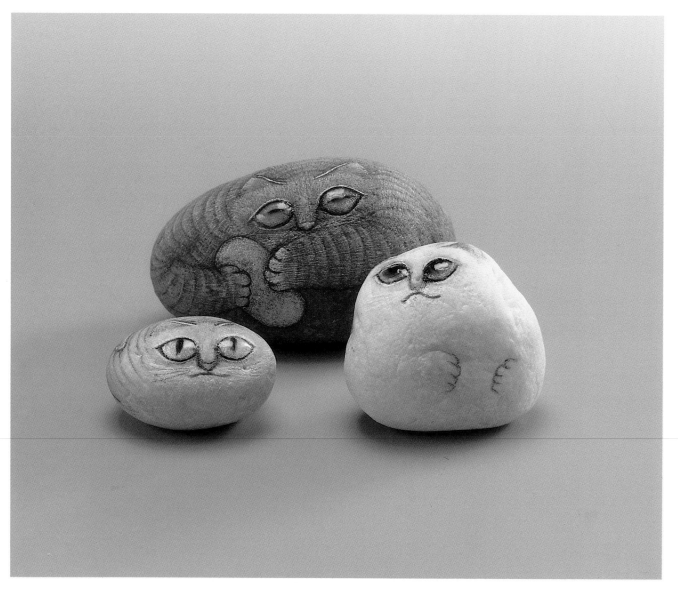

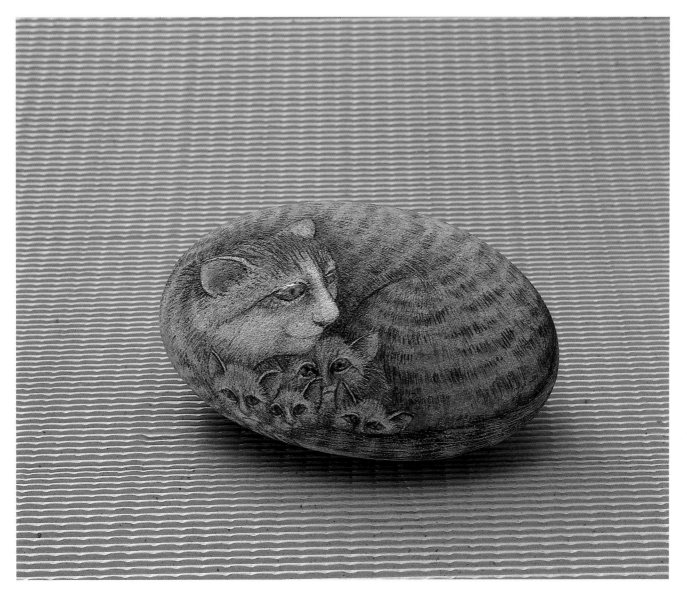

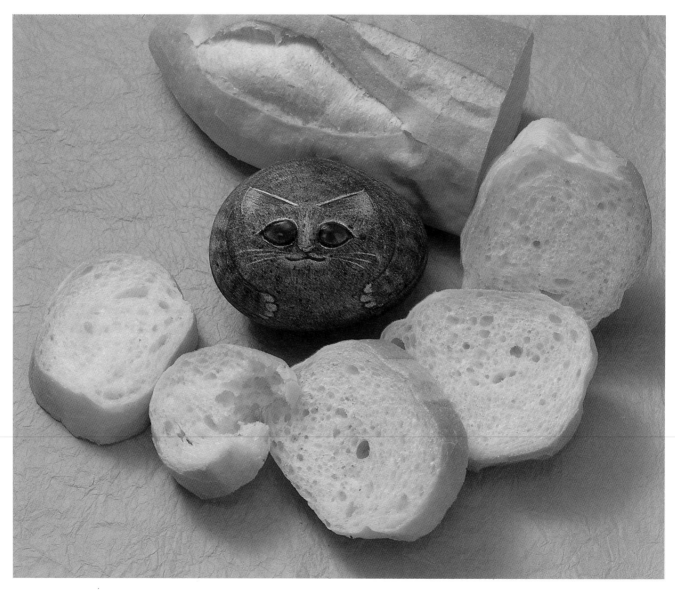

MAKING STONE CATS

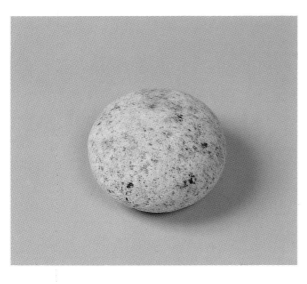

1. Gather stones with interesting shapes and markings from the beach or riverside. The idea is to avoid sculpting, so you should select stones with shapes and patterns that will lend themselves to becoming stone cats. Beginners should start with naturally polished stones of a size that fits conveniently in the hand. Wash and scrub the stones carefully and allow them to dry thoroughly, so that paint can be successfully applied.

2. You will need the following supplies: a pencil, fine brushes, clear nail polish, water colors, water-soluble marking pens, and wood glue.

3. Sketch the rough design of your cat, paying attention to the placement of the eyes, nose, ears, and legs. Make the best use of the natural shape of the stone, including any indentations, irregularities, or cracks. You can alter or redo your design as often as you like by simply erasing earlier attempts.

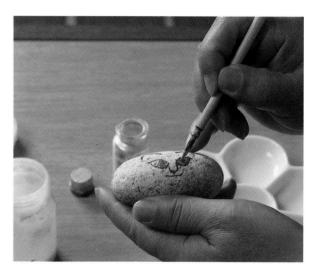

4. Paint the eyes with gold paint. A marking pen can be used, but gold powder applied with a brush will produce a more realistic depth. Be especially careful when painting the eyes, because your cat's expression will be determined by their shape and placement.

5. Paint in the distinctive feline pupils. Since you are using watercolor, you can allow it to seep into the stone for a more interesting effect. Remember, in the dark a cat's pupils are vertical slits, while during the day they are round. Choose the kind you wish to depict.

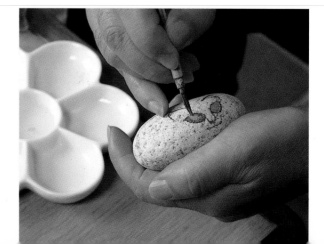

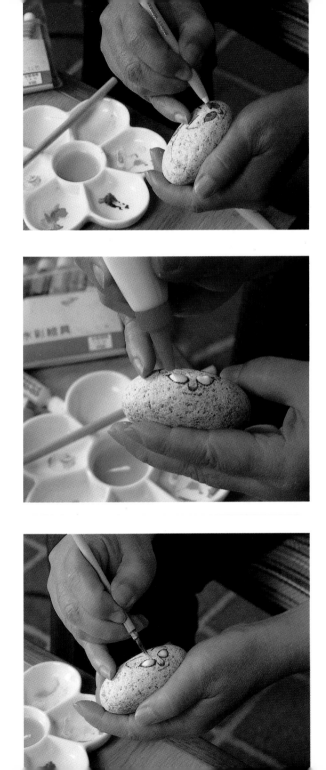

6. Trace the outlines of the eyes and ears with water-soluble marking pen, paints, and pencil. If you trace inside the outlines of the eyes with a light-colored (yellow, for example) marking pen, the wood glue that you apply over the eyes will blur the outlines a bit, creating an interesting effect.

7. Using a small bottle, cover the painted eyes with wood glue in a rounded, eye-shaped curve. You'll have to apply several coats to create the desired roundness, and because the glue will shrink while drying, you should try to build up a higher curve than you want in the finished eye. Be careful not to let the glue smudge outside the eye's outline, and let the surface of the first layer of glue dry before applying the next. A hair dryer will speed up the process. Though the glue is opaque and white when first applied, it will dry in two to three days into a transparent finish, allowing the colors beneath to show through.

8. Color the details of the other features with watercolors. Use a marker or brush for the outlines of the eyes, ears, feet, and tail, taking care to keep your lines from becoming too thick. This is easier to accomplish if you hold the brush perpendicular to the stone and move only the tip.

43

9. When the eyes have dried and become transparent, you can see what the cat will look like.

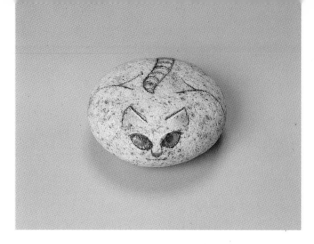

10. With a water-soluble marker, draw and color the pupils once more over the transparent glue, retracing the outlines of the eye.

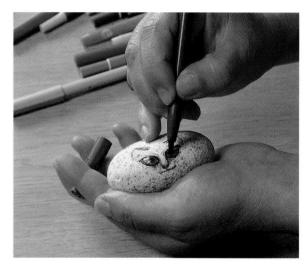

11. When the application of step 10 has dried, paint the eyes with clear nail polish to make them shine and look alive.

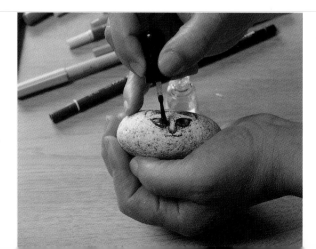

ABOUT THE ARTIST

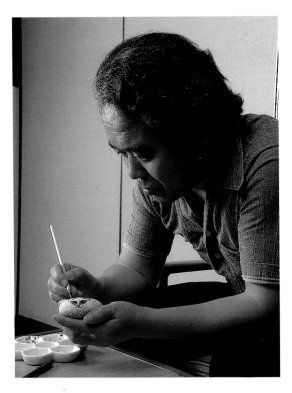

Nagata Yoshimi was born in 1944 in Nagasaki. He loved to draw from the time he was a child, and after graduating from high school he entered a dyeing workshop in Kyoto to study a technique of painting with dye known as *yuzen*. At twenty-nine he established his own dye workshop. In 1983 he went to Italy to study for a year, and after returning in 1985, he moved to Kobe. From about that time he became interested in the Noh theater and its costumes, and in 1986 three exhibitions of his paintings of Noh textiles and performances were held, in Kobe, Nagasaki, and Bologna.

It was in May 1987 that Nagata picked up a few pebbles while walking along the beach at Suma Bay and tried painting eyes and noses on them, creating his first stone cats. Since then he has held several exhibitions in Japan of his stone cats, dogs, birds, and other animals, and he and his work have been featured frequently on Japanese television.

 The "weathermark" identifies this book as a production of Weatherhill, Inc., publishers of fine books on Asia and the Pacific. Photographs by Sugimoto Masami. Typography, book, and jacket design: Liz Trovato. Production supervision: Bill Rose. Typesetting: Trufont Typographers, Hicksville, New York. Printing and binding: R.R. Donnelley, Reynosa, Mexico. The typeface used is Mixage.